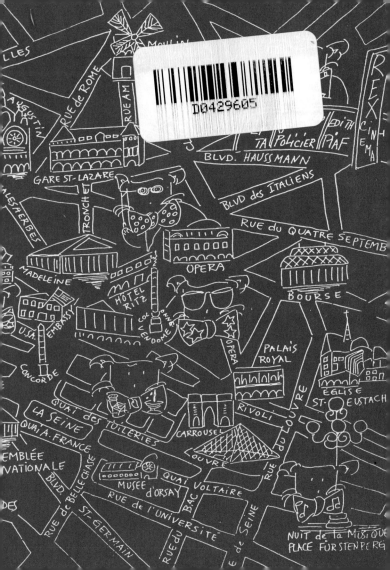

Paintbrush in Paris

Story and Illustrations by
Jill Butler

Workman Publishing, New York

Merci beaucoup . . .

*. . . à mes amis français qui m'ont permis de découvrir
leur vie quotidienne . . .* and to my American friends
who encouraged me to share my French experiences.
With special thanks to Margot Calder, Sally
Kovalchick, Barbara Delaney, Joe Rubin and Monica
Landry—and to Jean Meynial, without whom this story
would not have been told. Special thanks to Irene
Elmosnino for her *aide patiente et efficace.*

————————

Published simultaneously in Canada by Thomas Allen & Sons Limited.
LIBRARY OF CONGRESS CATALOGING-IN-PUBLICATION DATA
Butler, Jill.
Paintbrush in Paris : the artistic adventures of an American cat
in Paris / written and illustrated by Jill Butler.
p. cm.
ISBN 1-56305-524-4 :
1. Butler, Jill. 2. Paris (France) in art. I. Title.
ND237.B963A4 1994
759.13--dc20 94-6228
CIP

WORKMAN PUBLISHING COMPANY INC.
708 Broadway
New York, NY 10003

Manufactured in the United States of America
First printing May 1994

Departure

Deciding to leave my country and move to
France was no easy matter—but as an
artist I need the Challenge. Working in Paris
will force me to see things differently—and
being an outsider in a strange place always
gets the creative juices going.

I love my midwestern life-style, and I
know I'll miss my friends and favorite hangout
places. Most of all, I'll miss my studio. But in
Paris I'll have an *atelier*.

5

So . . . I'm moving.

NAME Mr. Paintbrush
SEX M Birthplace MICHIGAN
Birthdate 1.14.85
ISSUED NEW YORK 2.10.90
EXP. 2.10.2000
Minors
MON AMI
SIGNATU

I've packed up
my art supplies and
closed my studio.

My passport is ready and the tickets are bought.

6

They say if you want a friend in
France you'd better take one with you.
"Mon Ami," my toy cat, will come with
me and keep me company.

Knowing what else to take
is impossible. So the
decision is easily made
—I'll take it all!

*This I'll carry
on board ...*

*STUDIO
PAINTBRUSH*

... this I'll check through

*... and this I'll
send by boat*

FRAGILE
SUPPLIES

TOYS

TRANS.
ATLANTIC
SHIPPERS

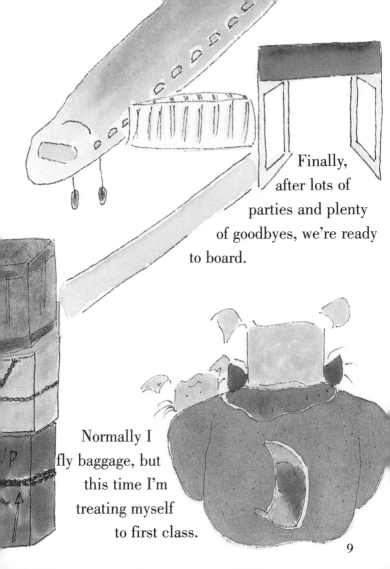

Finally, after lots of parties and plenty of goodbyes, we're ready to board.

Normally I fly baggage, but this time I'm treating myself to first class.

9

Look, here's Kalamazoo!
The world is pretty small.

moi
here

a 'monsieur'
next to me

We settle into our luxurious seats and let others take care of everything. They hang up our coats, give us gifts . . . and make sure we're comfortable.

They even serve champagne before takeoff.

This is a concept I can get used to!

11

champagne

château d'Eau

SEL POIVRE

TOAST

MENU

NEW YORK
PARIS

AF

AF

Homard et Asperges

AF

Salad always comes after the main course

Salade / trop vinaigre

12

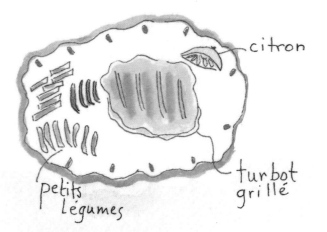

citron

turbot grillé

petits légumes

mousse au chocolat

sorbets

fruits

The first of many fine French meals: five courses, and two hours to enjoy them. I'm afraid I'll gain weight in France with all this good bread and wine.

le café

13

I curl up with "Mon Ami"
on my lap and read a
few pages of my book.

Listening to
music puts me
to sleep . . .

. . . but I'm so
nervous and excited I
can't even dream.

14

Le petit déjeuner

In no time at all, breakfast is served.
And then down we go . . .
(landing not crashing, I hope!)

★ PARIS

This part is easy enough:
getting through passport control
and finding our luggage.

16

BIENVENUE ◇ CHARIOTS
BAGAGES ◇ TAXIS

STUDIO
PAINTBRUSH

But now it's time to speak French,
which is not so easy . . .

18

19

I SPEAK FRENCH with a midwestern accent (as if I have a clothespin on my nose). Not to mention— I'm slightly intimidated to open my mouth in public.

Our taxi driver drives like a bullet train— and speaks like one, too. He also has an accent.

TAXI PARISIEN

5987W75

NOTE : Tips are always included in the price of everything : taxis, restaurants, coiffeurs.

We've been invited to live next to Maxim's.
Quelle chance!

The first few days I operate "on radar" and lots of coffee. I unpack my art supplies and start to set up my *atelier*.

After a while I venture out along the rue Royale, as far as the Tuileries, and check out the American Embassy* . . . just in case.

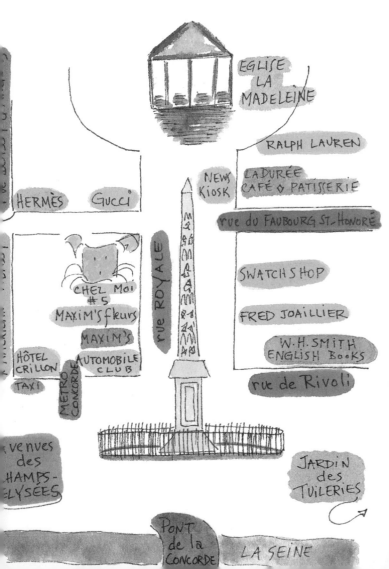

EGLISE LA MADELEINE

RALPH LAUREN

NEWS Kiosk

LADURÉE CAFÉ & PATISSERIE

HERMÈS GUCCI

rue du FAUBOURG St-Honoré

CHEZ MOI #5

MAXIM'S fleurs

SWATCH SHOP

MAXIM'S

FRED JOAILLIER

rue ROYALE

HÔTEL CRILLON

AUTOMOBILE CLUB

W.H. SMITH ENGLISH BOOKS

TAXI

MÉTRO CONCORDE

rue de Rivoli

avenues des CHAMPS-ELYSÉES

JARDIN des TUILERIES

PONT de la CONCORDE

LA SEINE

Being polite and correct is imperative, since all Americans are thought to be barbaric.

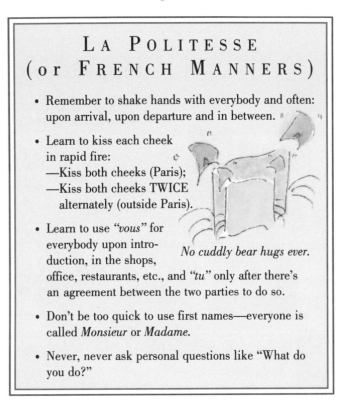

LA POLITESSE
(or FRENCH MANNERS)

- Remember to shake hands with everybody and often: upon arrival, upon departure and in between.

- Learn to kiss each cheek in rapid fire:
 —Kiss both cheeks (Paris);
 —Kiss both cheeks TWICE alternately (outside Paris).

- Learn to use *"vous"* for everybody upon intro-duction, in the shops, office, restaurants, etc., and *"tu"* only after there's an agreement between the two parties to do so.

No cuddly bear hugs ever.

- Don't be too quick to use first names—everyone is called *Monsieur* or *Madame*.

- Never, never ask personal questions like "What do you do?"

Nothing is familiar. Nothing looks
the same or is where it's supposed to be.
The simplest things
you take for granted
back home have to
be learned all
over again.

1. The street signs,
for instance. This
means the Champs-
Elysées is located in
the 8th of 20 neighbor-
hoods, or *arrondissements*.

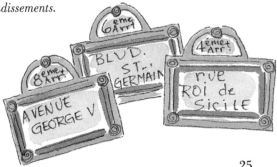

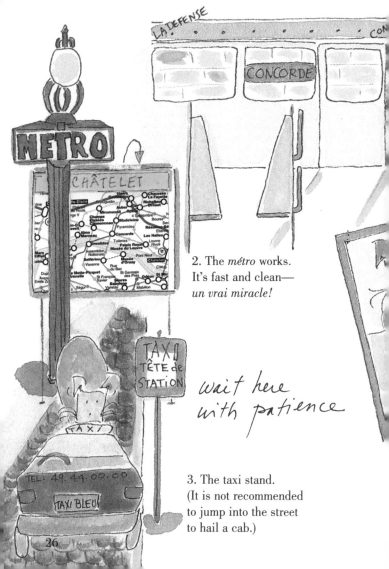

MÉTRO

CHÂTELET

LA DÉFENSE

CONCORDE

2. The *métro* works.
It's fast and clean—
un vrai miracle!

TAXI
TÊTE de
STATION

wait here
with patience

TEL: 49. 49. 00. 00

TAXI BLEU

3. The taxi stand.
(It is not recommended
to jump into the street
to hail a cab.)

26

CONCORDE

RATP 2 URBAINE 0000

RATP 2 URBAINE 0000

RATP 2 URBAINE 0000

RATP 2 URBAINE 0000

RATP 2 URBAIN 0000

4. Buy *un carnet*, or 10 tickets—good for *métro* and bus.

52 / 95

map here

6. Take a bus and get lost. This is the best way to explore the city—at least you're aboveground.

5. Photo machines are found down in the *métro*. (Every official or semiofficial paper needs a photo.)

27

7. The post office is unique:
a bank; an insurance company;
postal, fax and copy services.*

8. The phone card—
c'est génial! Buy a card at the post
office or *tabac* and call anywhere in
the world—up to the value of the card.

9. *Philatélie*—
buy stamps to collect (newest issues
only) or go to the stamp market or
the Musée de la Poste.

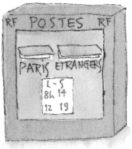

10. The *boîtes aux lettres*
hang on building façades.

*At *"la poste,"* you
can also buy stamps
and mail a letter.

28

11. Always a green cross for the drugstore, or *pharmacie*.

12. Menus are posted outside restaurants so you can see what you're getting into . . . beforehand.

13. Kiosks are now mostly decorative: poster displays and only occasionally a newsstand (replaced by the less interesting modern kiosks).

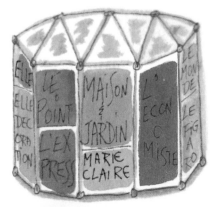

29

And now one more thing before I can really be here. Even an artist needs a *"carte de résidence"* to stay in France. Off we go to deal with *l'Administration.*

There are people from all over the world—I can tell by the shoes jabbing into me.

NIGHTMARE AT THE PRÉFECTURE DE POLICE

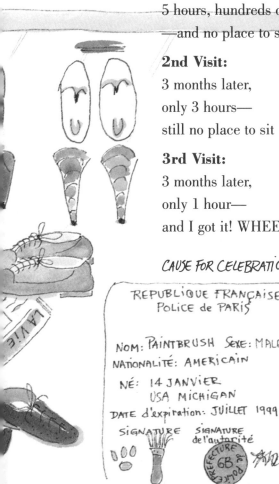

1st Visit:
5 hours, hundreds of people
—and no place to sit

2nd Visit:
3 months later,
only 3 hours—
still no place to sit

3rd Visit:
3 months later,
only 1 hour—
and I got it! WHEEW!

CAUSE FOR CELEBRATION!

REPUBLIQUE FRANÇAISE
POLICE de PARIS

CARTE
DE RESIDENT

NOM: PAINTBRUSH SEXE: MALE

NATIONALITÉ: AMERICAIN

NÉ: 14 JANVIER
USA MICHIGAN

DATE d'expiration: JUILLET 1999

SIGNATURE SIGNATURE
 de l'autorité

PHOTOGRAPH

Discovery

To REALLY
see Paris, you
must climb ever
monument and
take in the view.
"Mon Ami" is afrai
of heights, so his
views are closer
to the ground.

There's no doubt
about it: Paris is the
most beautiful city in the world.

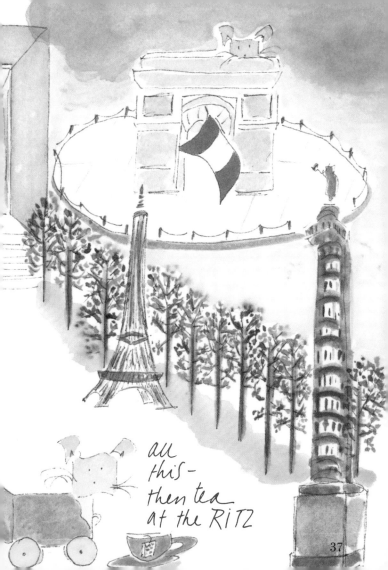

all this—
then tea
at the RITZ

37

Some days we just walk through the gardens and parks and check out the public art.

The contrast of traditional and contemporary architecture shocks the French, but I like the kind of tension it creates!

Les "Colonnes de Buren" dans les Jardins du Palais Royal

38

*La Fontaine
Stravinsky
de Jean Tinguely
et Niki de
Saint-Phalle*

I must check out:
Musée d'Art Moderne
 de la Ville de Paris
Musée d'Orsay
Musée de la Poste
Musée National Picasso
Centre Georges Pompidou
Musée des Arts Décoratifs
 and most important!
the Left Bank galleries
and the famous La Palette

Galerie Naif

GALERIE N. BELLIER

RIVE GAUCHE
Programme
des GALERIES

- Galerie ERVAL
- Galerie Naif
- Galerie Bellier
- Galerie des Beaux-Arts
- Galerie 1900-2000
- Galerie RIVE GAUCHE
- Galerie Didier

All artists
dream of
showing their
work on the
Left Bank.

One day I hope to see a
poster in the café window
announcing my
collage exhibition.

40

Galerie des Beaux-Arts

Art Contemporain

La Galerie est ouverte: 10h-19h Mardi-Samedi

6 Arr
rue des Beaux Arts

La Palette

Everyday Life

THE CAFE IS the viewing stand from which I watch the hustle and bustle of Paris and eavesdrop on the lives of those around me.

My biggest concern is not to drink too much coffee .

A café is both theater
and audience.
All life takes
place here.

I wonder
who's
watching
me?

Like everything else in Paris, ordering coffee is a special art:

sucre sur le bar

sucre enveloppé

croissant amande de CHEZ LADUREE

the coffee bowl used only at home

un express	⎫
un petit	⎬
un noir	⎭
un grand	⎫
un double noir	⎬
un petit crème	=
un café au lait	=
un café allongé	⎫
un café américain	⎬
un faux	⎫
un décaféiné	⎬
un vrai	=
un serré	=
un café noisette	=

Other things to order:

un chocolat chaud	=
un citron chaud	=
une infusion	=

three ways to ask for an espresso

un express

a double espresso

an espresso with milk
a double espresso with milk

un café au lait

a coffee with hot water
(usually on the side)

a decaffeinated coffee
(*faux* = false or fake)

a real coffee—caffeinated

very short and black

de l'eau chaude

an espresso with a drop of milk
(*noisette* = hazelnut)

une
carafe
d'eau
fraîche

hot chocolate

| NOTE : |
| Coffee taken |
| at the bar |
| is half-price |
| or less. |

hot lemon

herbal tea

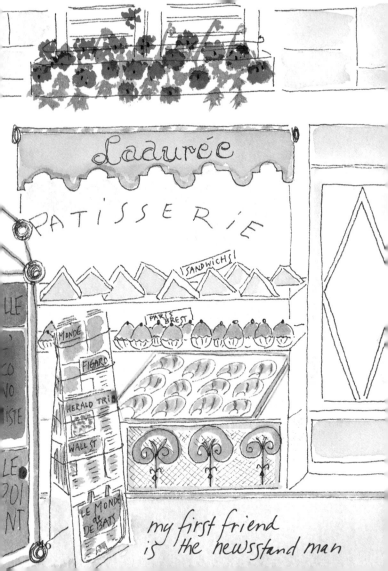

my first friend
is the newsstand man

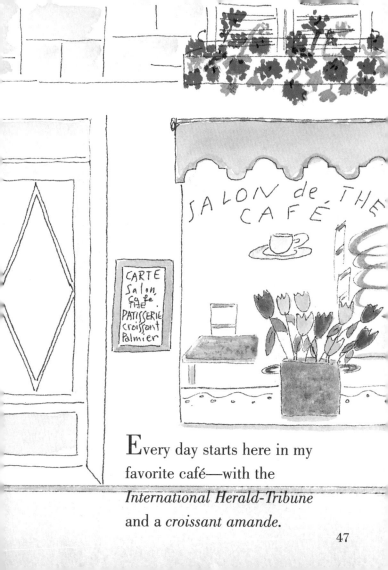

Every day starts here in my
favorite café—with the
International Herald-Tribune
and a *croissant amande*.

47

The angels painted
on the ceiling are what
I love most about this café.
They are bringing the bread.

I can stay here as long as
I want . . .

. . . except "*non-fumeur*" isn't
exactly respected.

49

When the smoke gets too much, I go to *le jardin*.

Les Tuileries
is a
user-friendly
park.

GARDENS ARE FOR ALL SEASONS

A winter *promenade.*

Driving in Paris is the last thing I wanted to do. However, one can have "fun" and maybe survive, if sufficiently competitive and combative.

Eyes closed: the best way to go around the Arc de Triomphe.

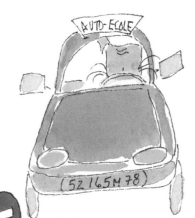

Clacking mirrors: the sign of a great driver.

RULES OF THE DRIVING GAME

- Drive the biggest, strongest car you can afford. (A tank will do fine.)
- Get mad, then get behind the wheel and vent your anger.
- Race to the light and wedge in between the cars already stopped.
- Wear your ego on the car hood.
- Dare the other driver not to stop.
- Leave only centimeters between you and the car in front of you.
- Barrel up behind the car in front of you . . . flash lights three times . . . put on the gas and pass.
- To relax before driving . . . drink only red wine.
- Park anywhere—especially on the sidewalk.
- Never, ever give the right of way.
- Don't bother to be polite—you'll never meet these people socially.
- Don't drive in Paris unless absolutely necessary.

Attention pedestrians! You only THINK you have *la priorité*.

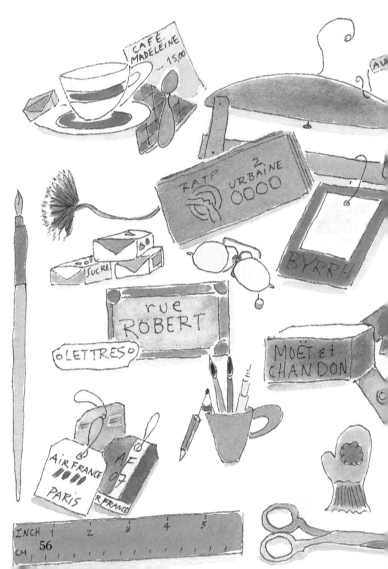

Getting to Work

GETTING TO WORK includes
first collecting "selective"
junk and *objets trouvés*
from friends' *greniers*
and serious shopping
at the *brocantes*
and flea markets.

TREASURE HUNTING

1. A favorite day is shopping for collage materials. An early start is a must at the Clignancourt Flea Market (Sat. Sun. Mon.). METRO: Clignancourt.

POSTE d'INCENDE

ALLEE 2

Reille & Co.

blanchet

ANTIQUITE ANGLAIS

NATLYNE

2. Each market has its own personality. Marché Dauphine has both antiques and *brocantes*; the Marché Vernaison has good collage junk; the Marché Bir is best for quality antiques.

3. Lunch at Chez Louisette, Allée 10, Marché Vernaison, is both convenient and authentic.

4. A small detour at the market for clothes, boots, scarves and souvenirs proves worthwhile.

5. St-Germain-des-Prés is direct on the *métro* for an end-of-the-day coffee at the Café Aux Deux Magots. The cat and the music box are *bizarre*, but fun; people-watching is worth the price.

6. The last stop is just across the Boulevard St-Germain, to buy a footbath at Le Drugstore.

UNIVERSITÉ de PARIS

PARIS

Why do I feel like a tourist?

RUE ROB

What better place than Paris to shop for art
materials? Everything is beautifully displayed
in wonderful old shops—and you can discover
new kinds of papers and materials.

Different kinds of stores:

- *un magasin* = a store

- *une boutique* = a small store

- *magasin des beaux-arts* ⎫ an art
- *matériaux pour artistes* ⎬ supply
- *couleurs pour artistes* ⎭ store

- *librairie* = a bookshop
 Not to be confused with
- *bibliothèque* = a library

- *papeterie* = lightweight office
 supplies mixed with some fun stuff

- *papeterie de bureau* = office supplies
 (heavy-duty)

- *brocante* = a junk shop,
 low-grade antiques

- *marché aux puces* = a flea market

To window-shop
in French is
lécher les vitrines,
or "lick the
windows."
(I like this idea.)

60

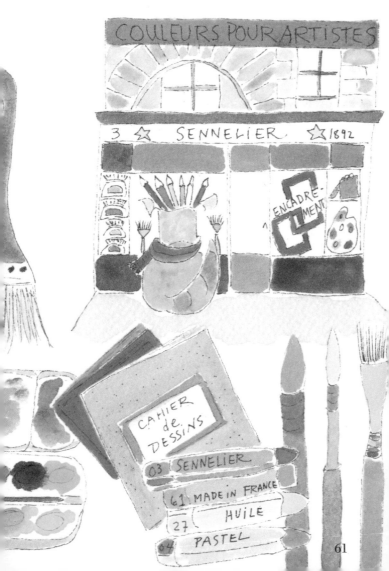

61

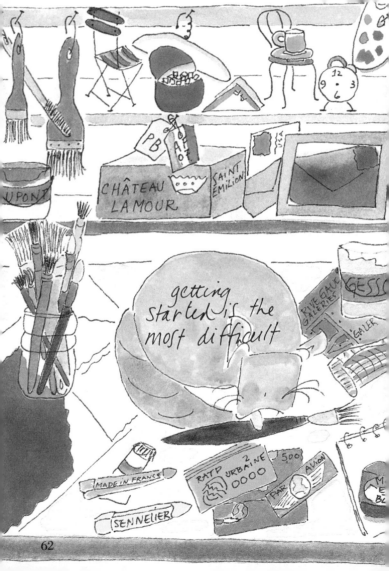

getting started is the most difficult

Eventually everything finds its way to my *atelier*. And I'd better get to work or they'll never give me a show!

Food as Art and Religion

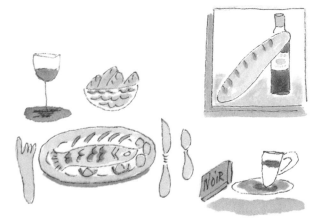

TWO HOURS OR MORE—
or it isn't a "proper" meal.

Just a light lunch
 includes:
a glass (or two) of wine
bread
an hors d'oeuvre or salad
a fish with vegetables
a dessert
coffee avec *un petit
 morceau de chocolat
 noir*

Lunch
on a
park
bench
doesn't count.

Lord
Sandwich

ORANGINA

Ville
de
PARIS

65

POISSONNERIE

Shopping for fresh foods is a daily ritual.
The presentation is spectacular—fruits
and vegetables lined up like soldiers—
But don't touch! or squeeze!

LES FLEURS de MARIE ANTOINETTE

Wait your turn
to be served
or risk being
reprimanded.

*and
don't forget
the flowers*

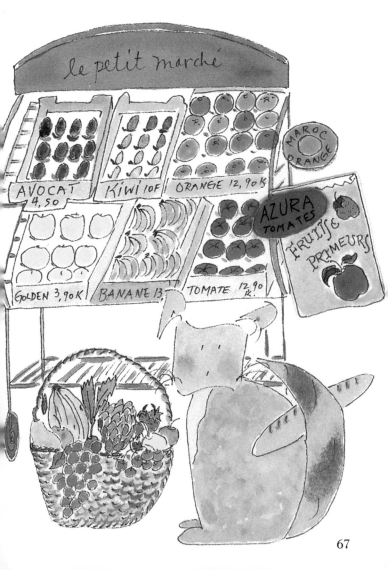

67

68

But then, why cook when there
are *traiteurs*, or caterers, who
create splendid prepared foods
ready to go?

Or skip the main course altogether
and go directly to dessert . . .

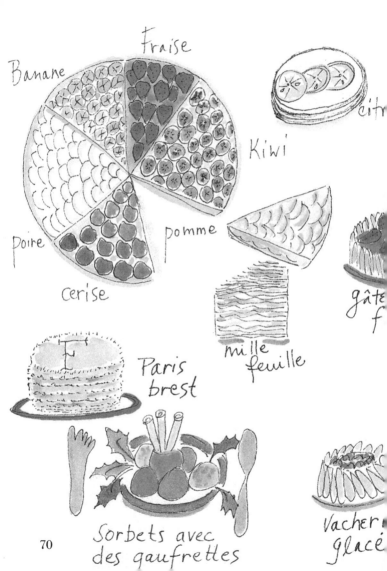

Fraise

Banane

citr

Kiwi

Poire

pomme

cerise

gâte
f

mille
feuille

Paris
brest

Sorbets avec
des gaufrettes

Vacher
glacé

In France, you don't have to
be embarrassed to eat dessert—
what a relief!

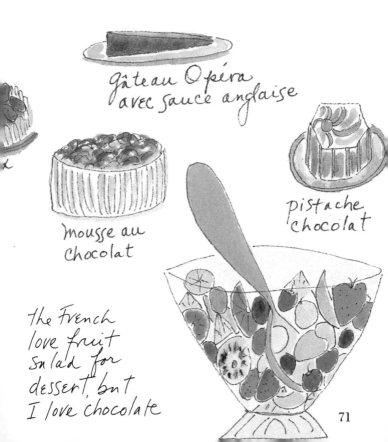

gâteau Opéra
avec sauce anglaise

mousse au
chocolat

pistache
chocolat

the French
love fruit
salad for
dessert, but
I love chocolate

71

DÎNER
5 SEPT.
21 heure

THERE'S A GOOD CHANCE you'll be invited
to a Big Deal dinner, or *"le grand dîner."*
It's important to know the rules . . .

la flute

le ballon

... which, if you're French, are second nature, but if not, take note ...

verre à orangeade

verre a eau

la tulipe

le petit verre

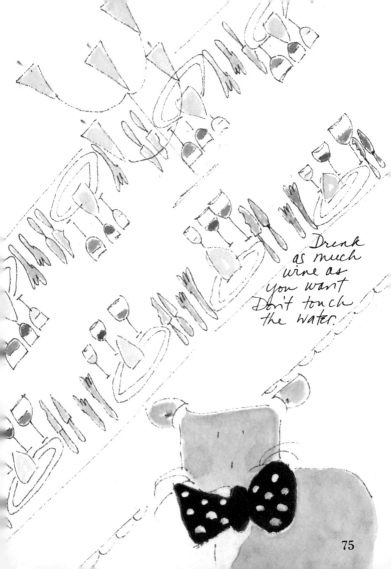

Drank
as much
wine as
you want
Don't touch
the water.

75

PROPER BEHAVIOR
FOR "LE GRAND DÎNER"

- Never arrive on time. The hostess will still be in her bath.

- Send flowers ahead—don't carry them with you.

- Pretend you're going to a dinner-spectacle. Enjoy the "show."

- Everybody is called "*monsieur*" or "*madame*." Don't bother to learn their names—they won't bother to learn yours.

- Don't be looking to make a new friend and don't expect ever to see these people again.

- Get interested in wine, cheese and politics, or you'll be left out.

- Be prepared to talk about your last or next vacation.

- Keep your hands on the table (not on your lap) or people will think the worst.

- Don't ask for a recipe—it's the hostess's work of art.

Velveeta cheese is not a choice.

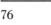

- When asked if smoking bothers you, say yes. (Don't worry, they'll smoke anyway.)

- As a foreigner, be warned that some might not want to make the effort to understand your French.

- When frustrated with French, say it in English—most will understand.

- Dress to kill! The women will hate you anyway, and at least the men will talk to you.

- Learn to smile and seem very interested even when you don't understand a word (or could care less).

- Accept the fact that people smoke cigars after dinner. Move to the kitchen if necessary.

- Start to leave only after coffee, cigars, cognac and fruit juice have been consumed.

- Thank-yous require being imaginative and "correct"— prepare in advance a choice of things to say.

- Congratulate yourself on having navigated through another "*grand dîner*"!

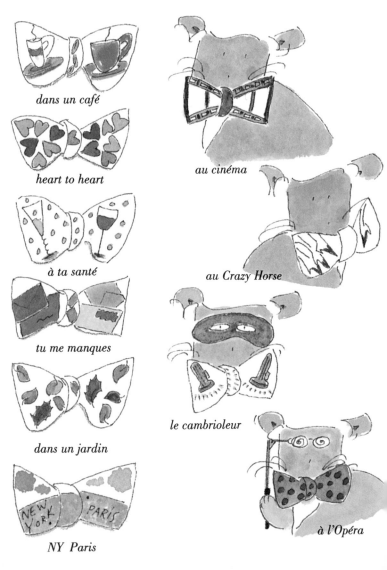

dans un café

heart to heart

à ta santé

tu me manques

dans un jardin

NY Paris

au cinéma

au Crazy Horse

le cambrioleur

à l'Opéra

An elegant wardrobe is a must for a night on the town in Paris. As long as I can't be entirely *"en grande peau,"* I've created a wardrobe of *papillons.* As an artist, it's more than O.K. to add a touch of originality.

star gazing

happy birthday

auto-portrait

en Bateau Mouche

le peintre

je t'attends

franco-american

stop and go

Homesick

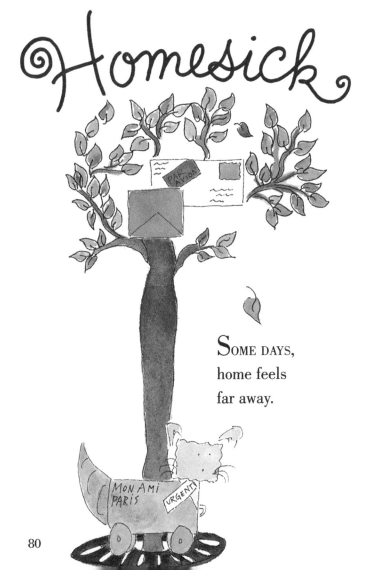

Some days,
home feels
far away.

MON AMI
PARIS

URGENT

When I feel lonely,
I go to a café
where there are
lots of tourists
speaking
English.

ORAN
GINA

PB

ATELIER

Café

81

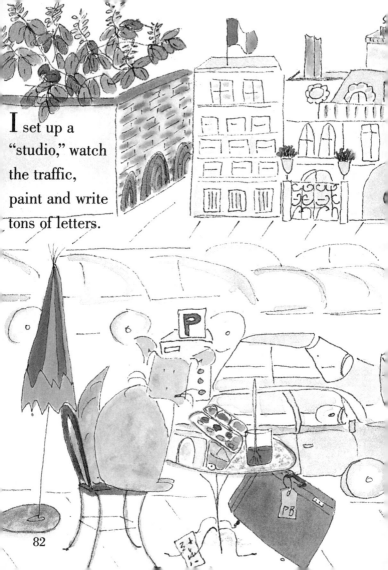

I set up a "studio," watch the traffic, paint and write tons of letters.

82

but calling is faster

83

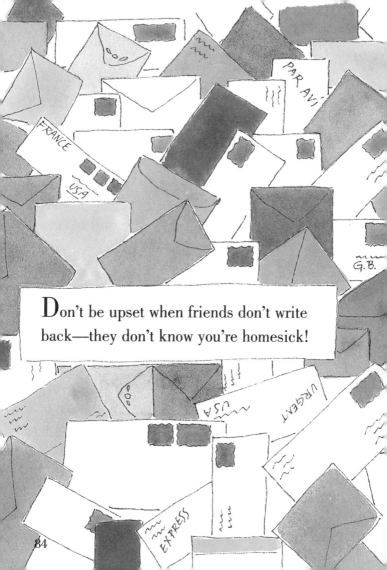

Don't be upset when friends don't write back—they don't know you're homesick!

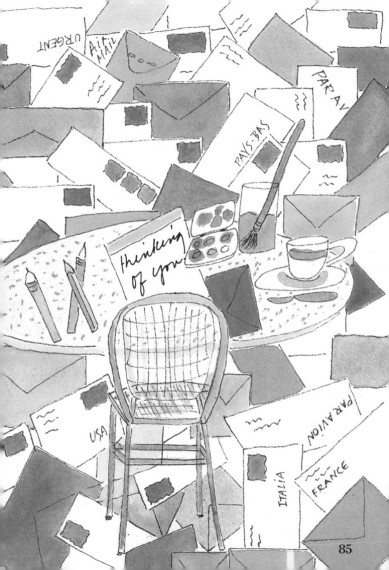

Exhibition

THE TELEPHONE
"rings" and things
don't feel so
lonely . . .

I've been invited to exhibit my
collages on the Left Bank—
a dream come true!

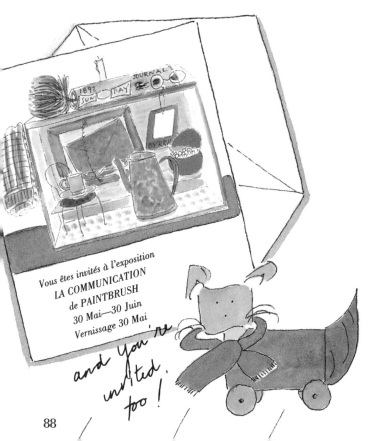

Vous êtes invités à l'exposition
LA COMMUNICATION
de PAINTBRUSH
30 Mai—30 Juin
Vernissage 30 Mai

and you're
invited
too!

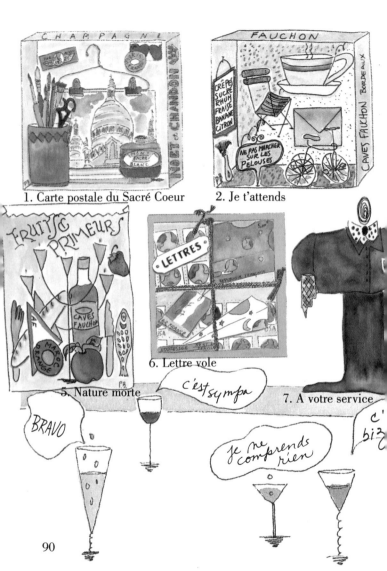

1. Carte postale du Sacré Coeur

2. Je t'attends

5. Nature morte

6. Lettre vole

7. A votre service

3. Souvenirs des jardins

4. Dans l'atelier

8. From Kazoo to the Louvre

j'aime beaucoup

91

Being acknowledged
as an artist in a
foreign country
has added meaning.

Paintbrush's Paris by Night

MALESHERBES-

VILLIER

BOULEVARD de

PARC MONCEAU

RUE de MONCEAU

←VERS LE BOIS de BOULOGNE

AVENUE des TERNES

AVENUE HOCHE

RUE du FAUBOURG

St. Philippe du Roule

BLVD. St. Philippe du Roule

HAUSSMA

AVENUE HOCHE

AVENUE du FAUBOURG

RUE L

ST. HONORÉ

AVE. FOCH

ARC de TRIOMPHE

AVENUE

PONTHIEU

ÉLYSÉE

GABRIEL

AVE. VICTOR HUGO

des CHAMPS-ÉLYSÉES

AVE GEORGES V

CRAZY HORSE

INK

PIERRE de CHAILLOT

MUSÉE GALLIERA

RUE BOISSIERE

AVENUE KLEBER

LASERING

GRAND

COURS

AVE du PRES. WILSON

NEW YORK

LA SEINE

Le BATEAU MOUCHE

QUAI d'O

PALAIS de CHAILLOT

AVE.

LA MOTTE-PICQUET

TOUR MAUBURG

KENNEDY

TOUR EIFFEL

Restaurant JULESVERNE